DRAW 50 | Animal 'Toons

The Step-by-Step Way to Draw Dogs, Cats, Birds, Fish, and Many, Many, More . . .

BOOKS IN THIS SERIES

DRAW 50 Animal 'Toons

The Step-by-Step Way to Draw Dogs, Cats, Birds, Fish, and Many, Many, More . . .

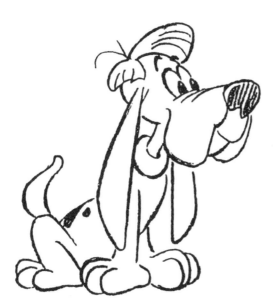

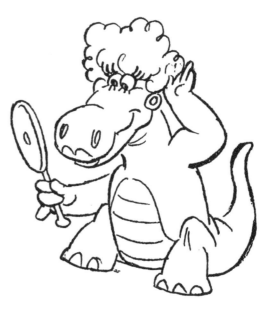

LEE J. AMES
with Bob Singer

Watson-Guptill Publications, New York

The Library of Congress has cataloged this book as follows:

Ames, Lee J.
 Draw 50 animal 'toons / Lee Ames and Murray Zak—1st ed.
 p. cm.
 1. Cartooning—Technique. 2. Animals—Caricatures and cartoons.
I. Zak, Murray. II. Title.
NC1764.8.A54. A47 2000
741.5—dc21
 00020750

ISBN 978-0-8230-8577-4
eISBN 978-0-307-79833-6

Printed in the United States of America

10 9 8 7 6 5 4 3 2 1

This book is dedicated to my dear wife Harriet,
Our five children,
Six grandchildren,
And to the "hummers," you know who you are!
—Lee J. Ames

Introduction
Drawing Tips

The lessons in this book show you how to draw cartoon animals. You can start anywhere in the book you like. Simply select a cartoon and follow the step-by-step method shown to create your drawing of it. On a separate piece of paper, very lightly and carefully sketch out step one. Although this step is the easiest, it is also the most important and should be done the most carefully. Step two shows you how to build on step one by adding sketching. This should also be done lightly and very carefully. Step three is lightly added right on top of step two. Continue this way to step four, the last step, which should be drawn firmly!

It may seem strange to ask you to be extracareful when you are drawing what seem to be the easiest first steps, but this is most important. A careless mistake at the beginning may spoil the whole picture at the end. As you sketch out each step, watch the spaces between the lines, as well as the lines, and see that they are the same as in the book. After each step, you may want to lighten your work by pressing it gently with a kneaded eraser (available at art supply stores). Just lighten the portions that have become too dark, don't make your lines invisible!

When you have finished your drawing, go over the final step in india ink with a fine brush or pen. When the ink is dry, use the kneaded eraser to clean off the pencil lines. The eraser will not affect the india ink. This is the way professional illustrators work.

Here are some suggestions: In the first few steps, hold your work up to a mirror. Sometimes the mirror shows that you've twisted or distorted the drawing off to one side without being aware of it. At first you may find it difficult to draw the lines, the egg shapes, the ball shapes, or sausage shapes, or to just make the pencil go where you wish. Don't be discouraged. The more you practice, the more you will develop control.

Although the only equipment you need to create beautiful drawings is a medium or soft pencil, paper, the kneaded eraser, and, if you wish, a pen or fine-pointed brush, you may also want to try using the Draw 50 series with your computer. The best way to use the Draw 50 series with a computer is with an electronic pencil and pad program, such as artPadII, Dabbler, or Painter (#4 or 5). Computers offer some advantages, not the least of which is the "Undo" command (not available with regular india ink!). On a computer, you can erase as many times as you wish without damaging the "paper" and you can print as many copies of your drawing as you like. You may also want to draw your images

using pencil and paper, then use a scanner to create an electronic version you can color and manipulate with a painting program.

There are many ways and methods to make drawings. My books show some of my favorite methods. There are other books—like those by my friend Mark Kistler—that show other exciting techniques. If you enjoy the Draw 50 series, I urge you to explore other ways to draw from teachers, from libraries, and most important . . . from inside your own imagination.

—LEE J. AMES

DRAW **50** ANIMAL 'TOONS

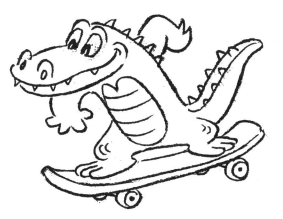

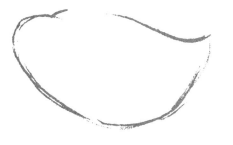
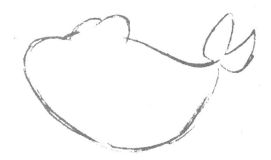
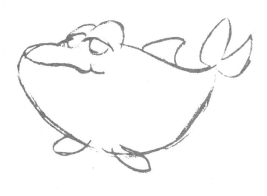
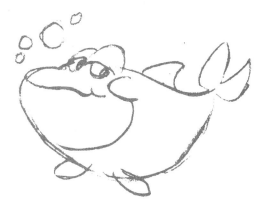
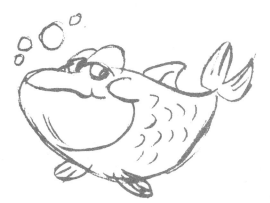
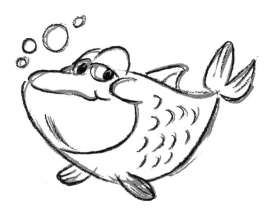

Mini Winnie Minnow

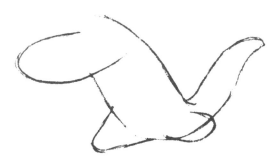
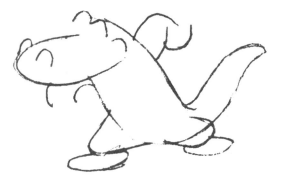

Al E. Skater

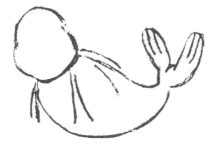

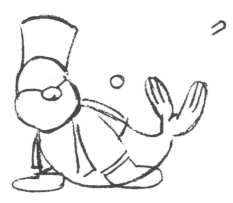

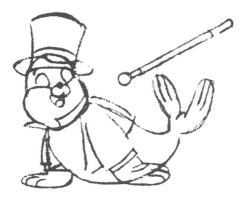

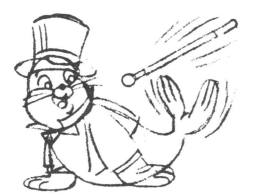

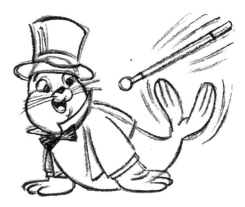

Emil McNeil, the Juggling Seal

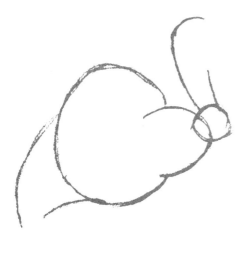
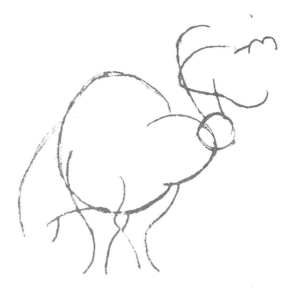
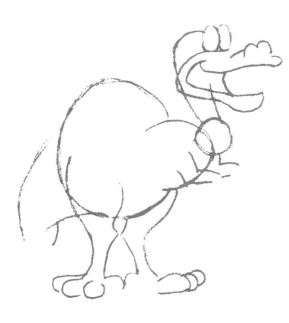
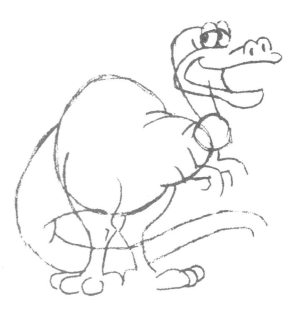
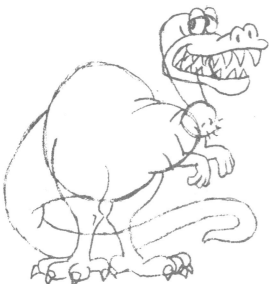
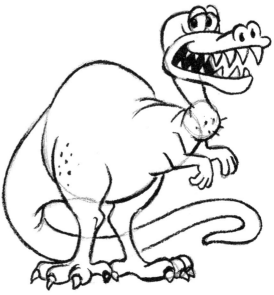

Danny Sore

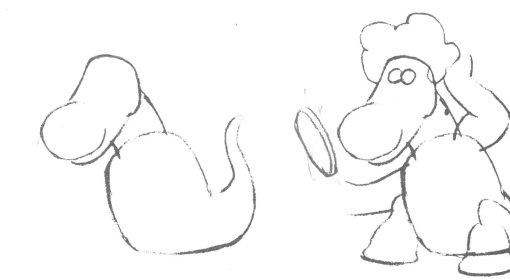

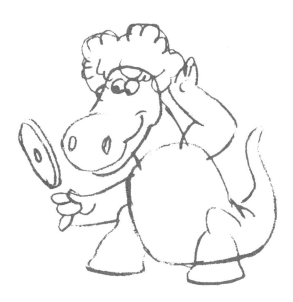

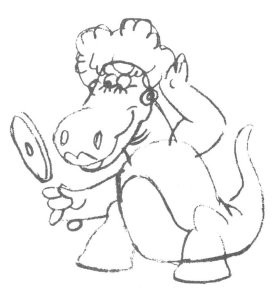

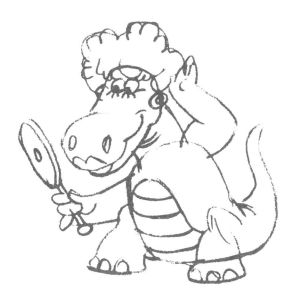

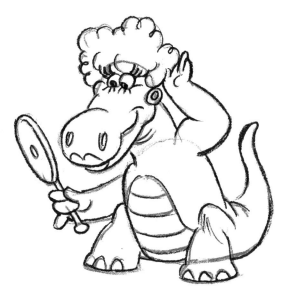

Dinah Soar

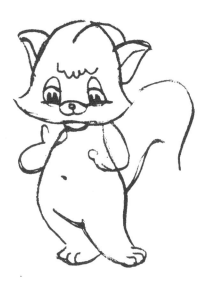
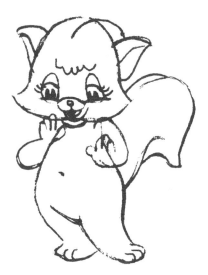
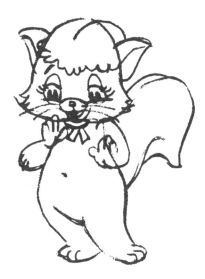
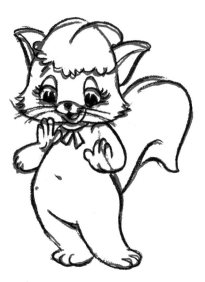

Kitty Little

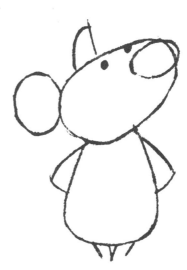
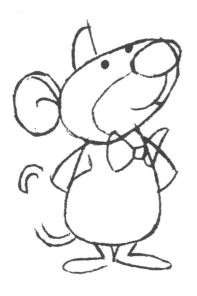
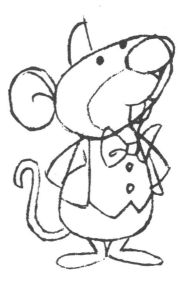
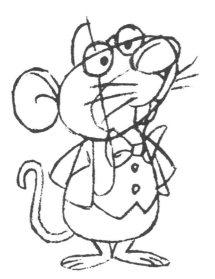
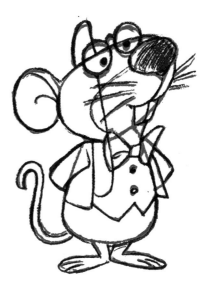

Professor Squeaks

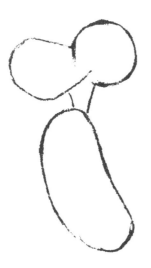
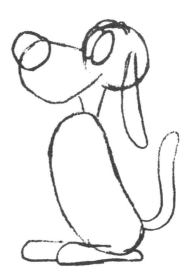
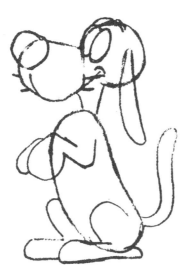
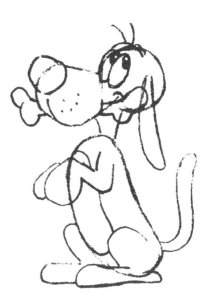
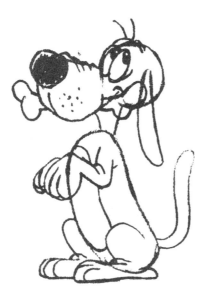
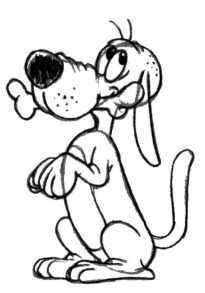

Buddy Beaglebeggar

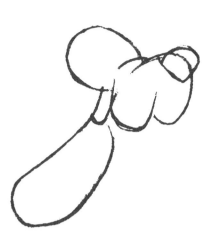
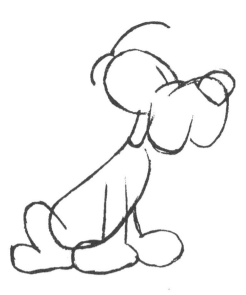
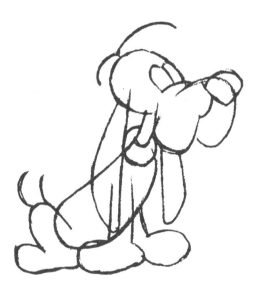
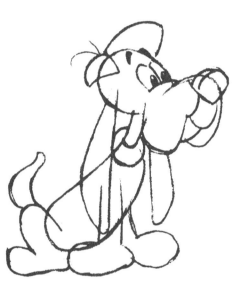
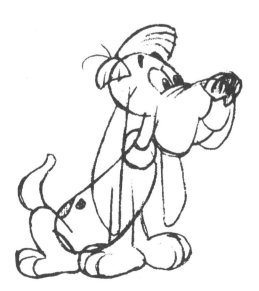
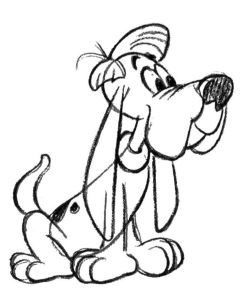

Smoochy Pooch

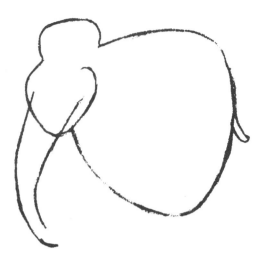
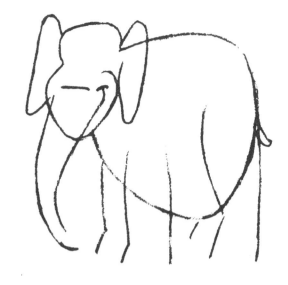
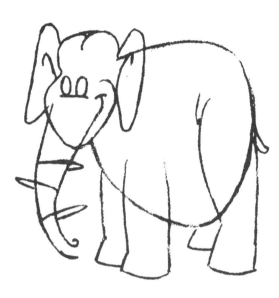
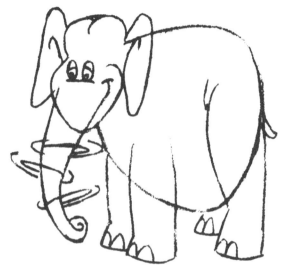
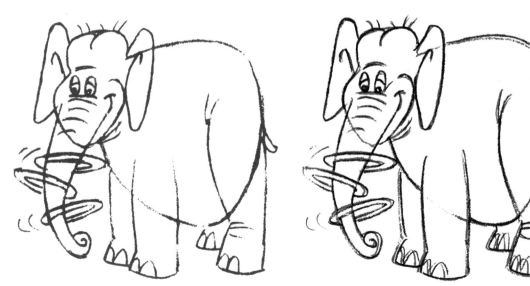

Hoop Spinner, L. F. Aunt

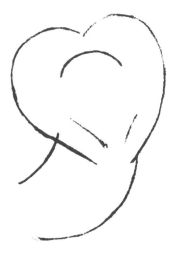
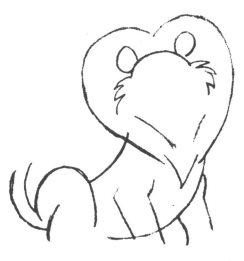
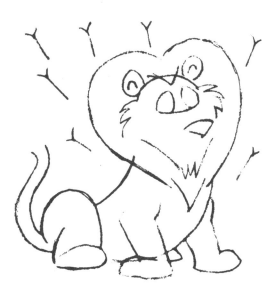
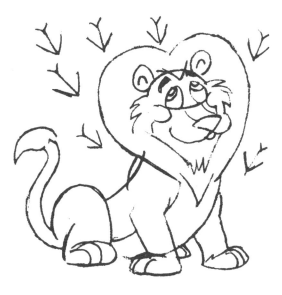
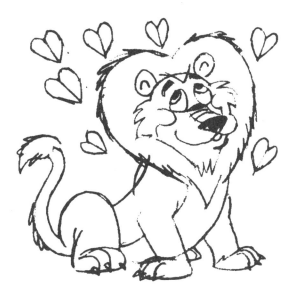
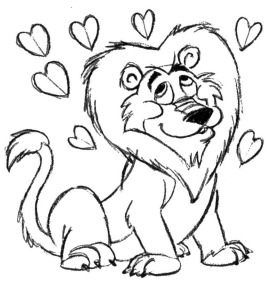

Lover Leo

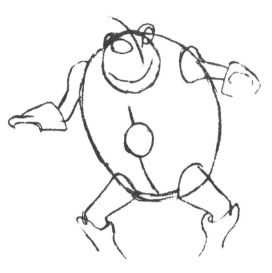
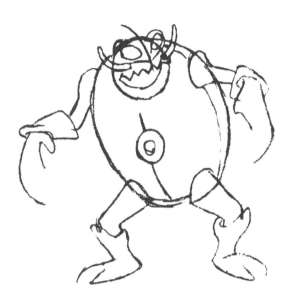
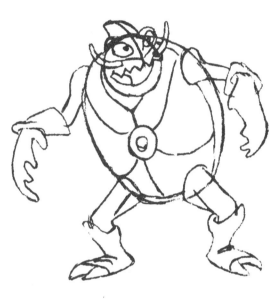
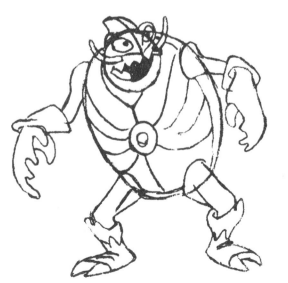
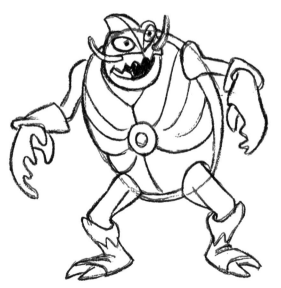

Brutal Beetle Boo

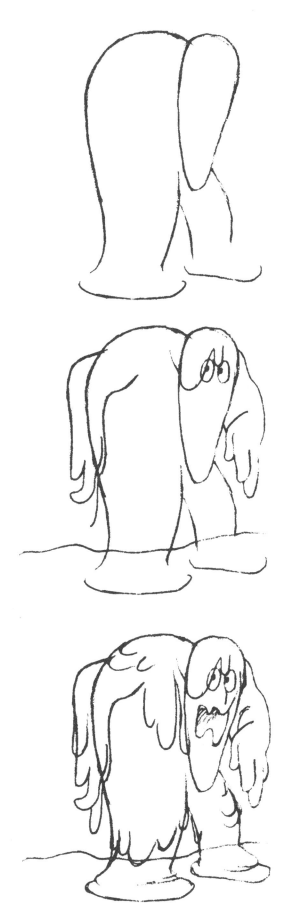

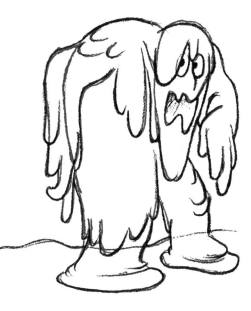

Mel Ted Goop

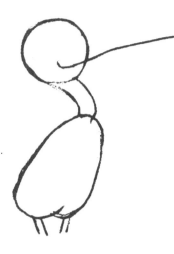
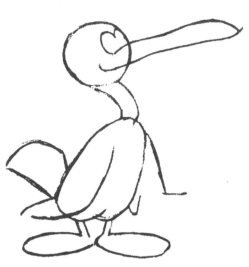
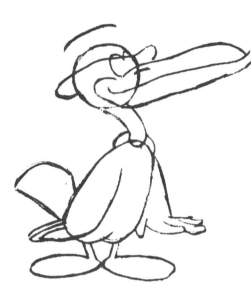
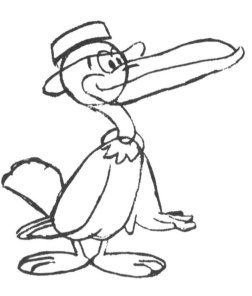
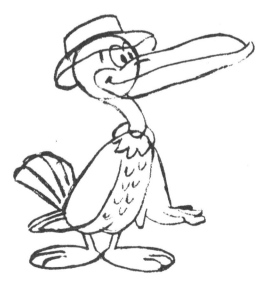
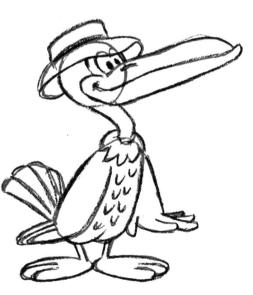

Pelican Pete with the Chic Beak

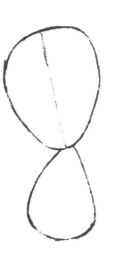

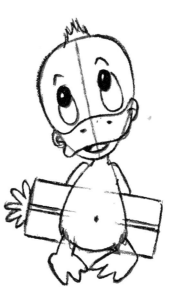

Cheepy Chicklette

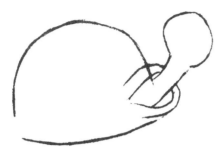
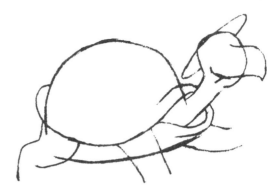
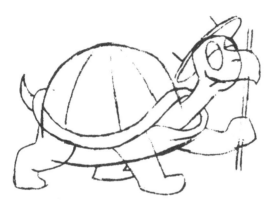
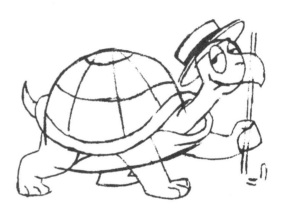
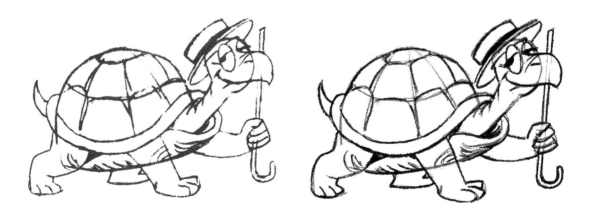

Burt L. Turtle

Sybil Sea Monster

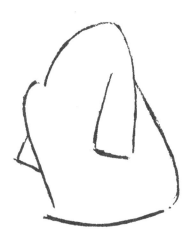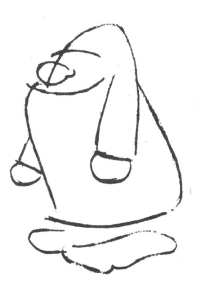

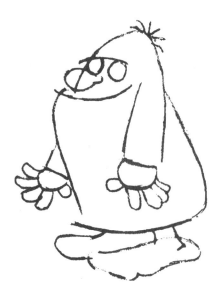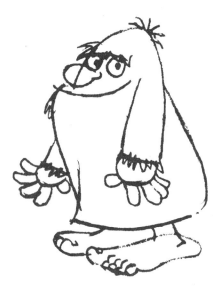

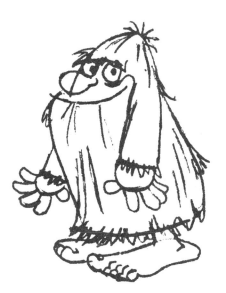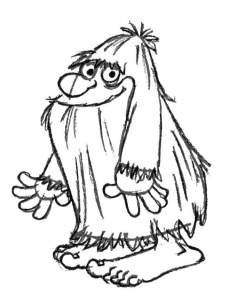

Whitcomb Woolly Whiskers

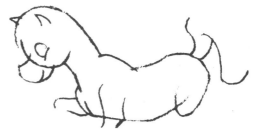
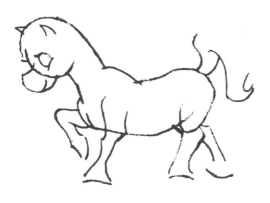
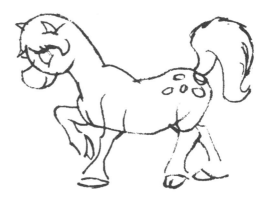
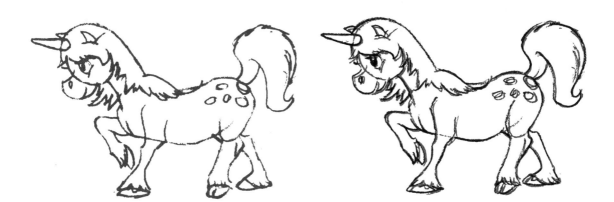

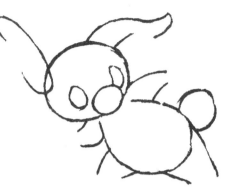
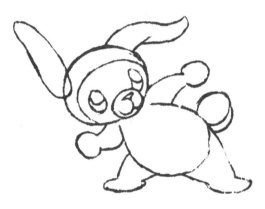
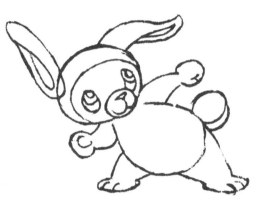

Bunny Beanbag

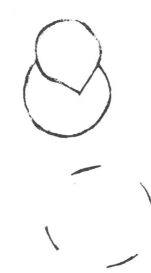
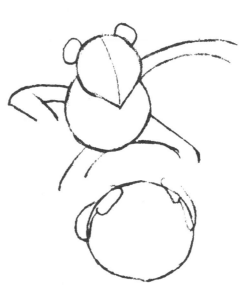
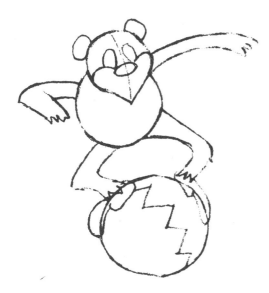
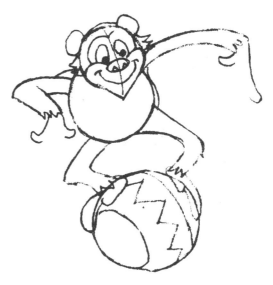
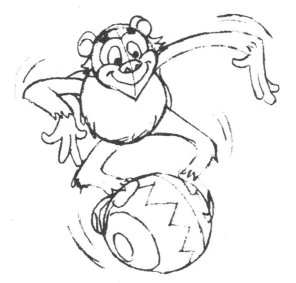
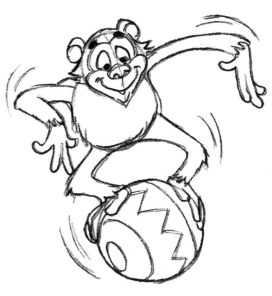

Funk Monkey, the Acrobat Junky

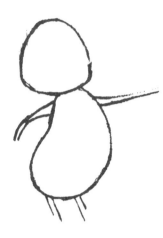
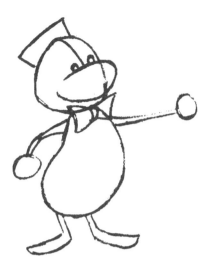
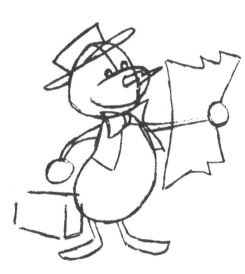
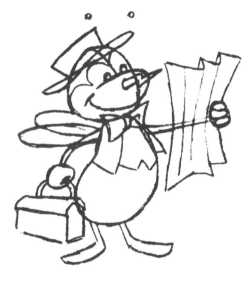
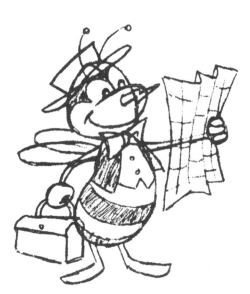
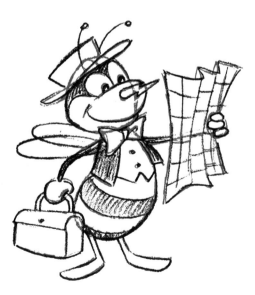

Traveling Sales Bee

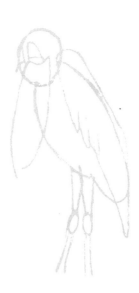
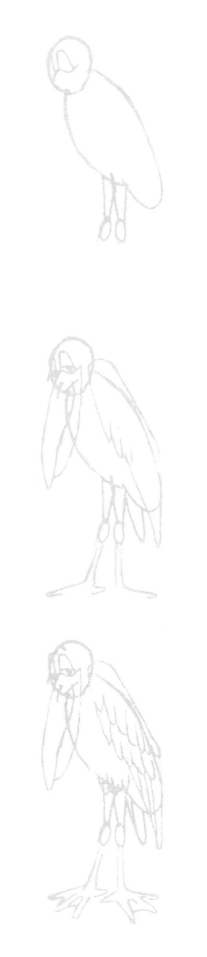
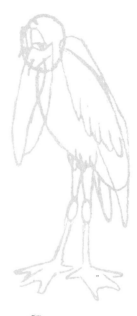
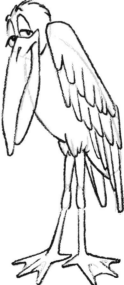

Sorry Sammy Stork

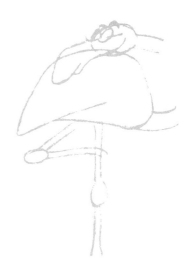

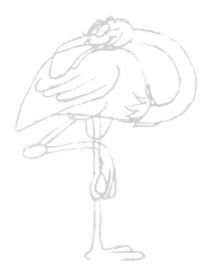
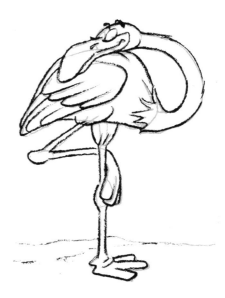

Wambingo Flamingo

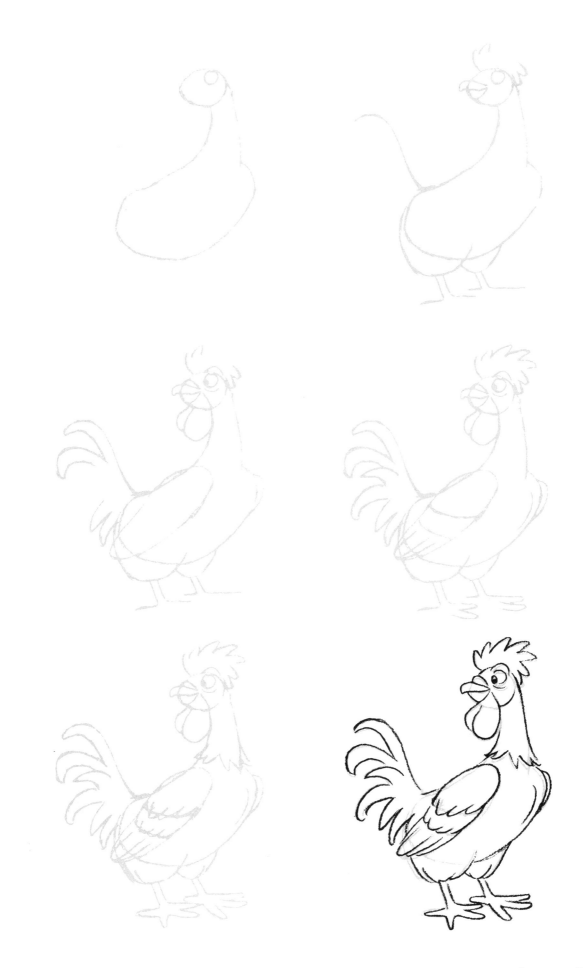

Kooky Doodle Doo

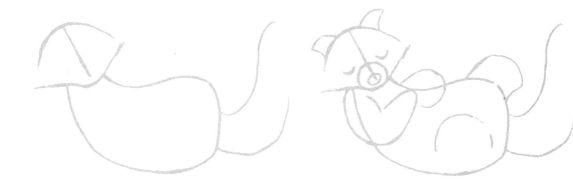

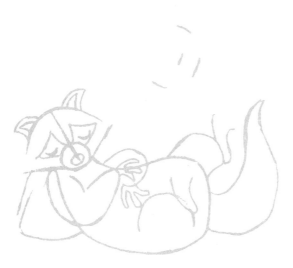

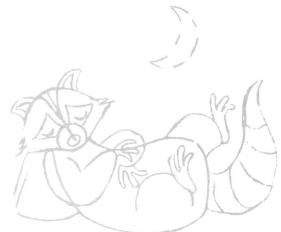

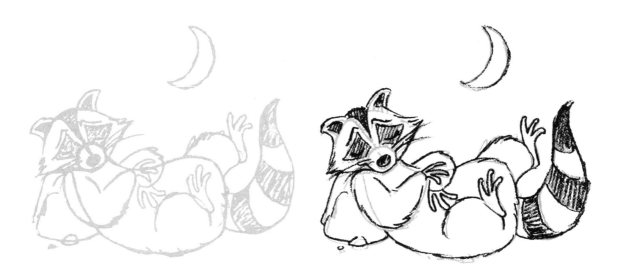

Sleepy Raccoon

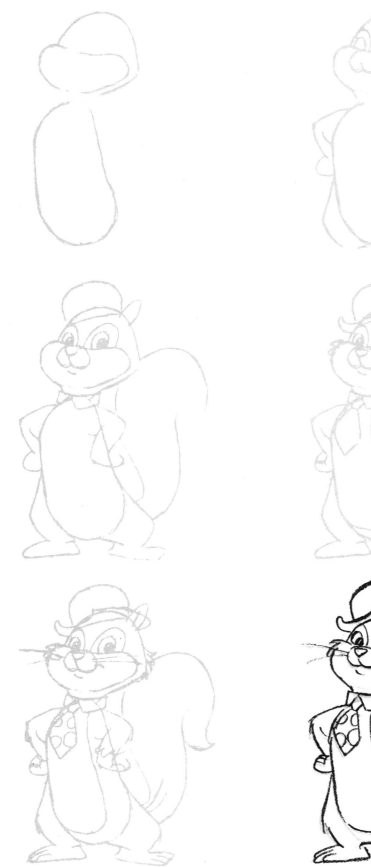

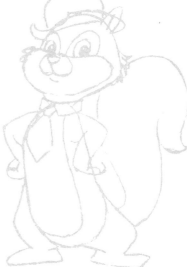
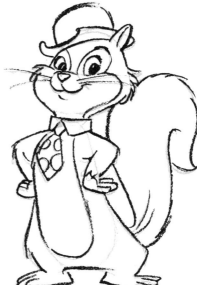

Squire Squiggly Squirrel

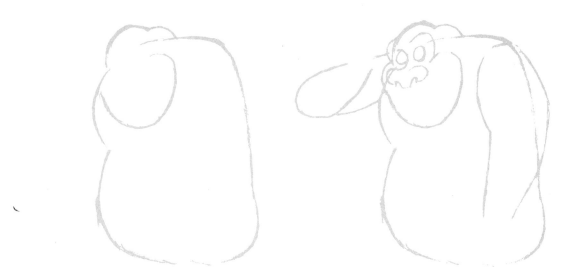

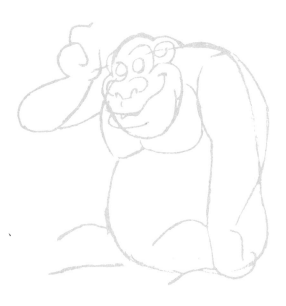
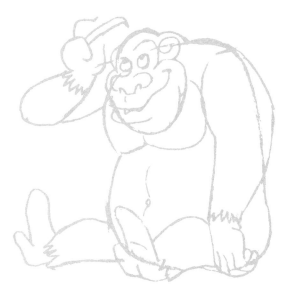

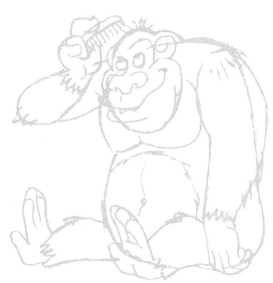
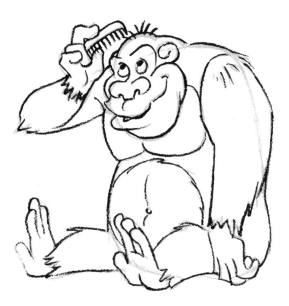

Sir Gareth, the Neat Gorilla

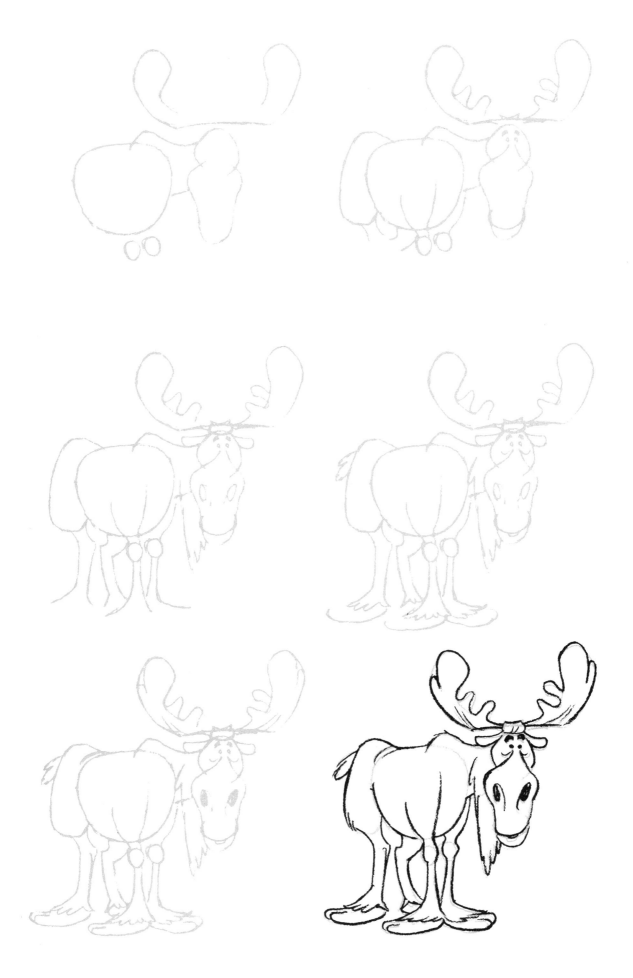

Muggy Moose

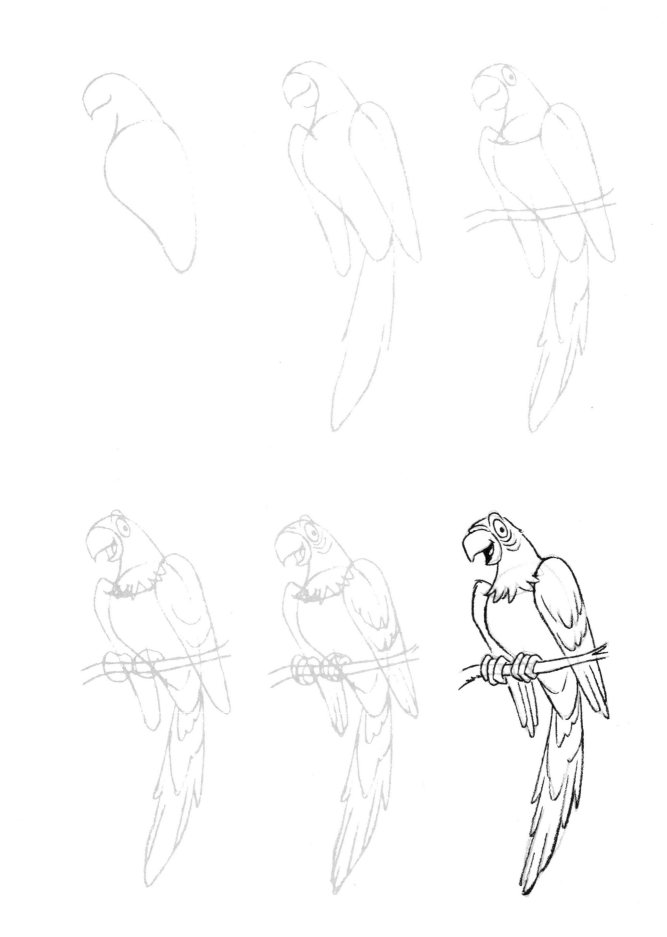

Squawkie Mouth Macaw

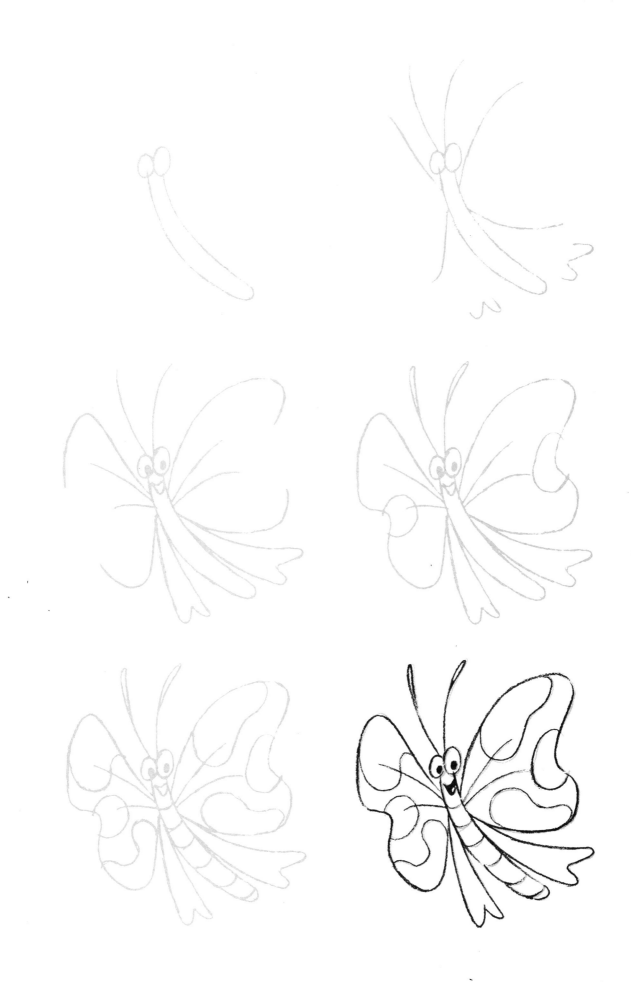

Fanny Flutter By

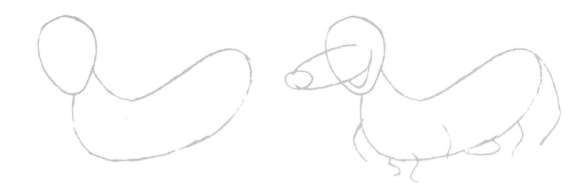

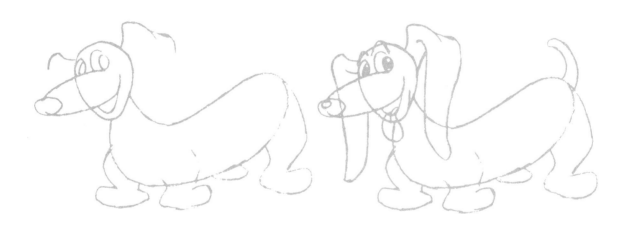

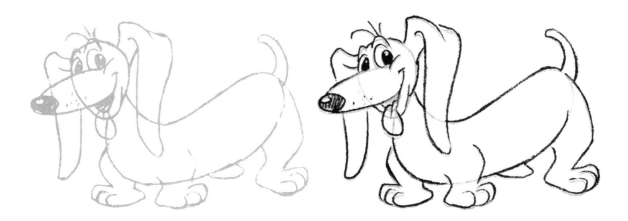

Frank E. Phooter

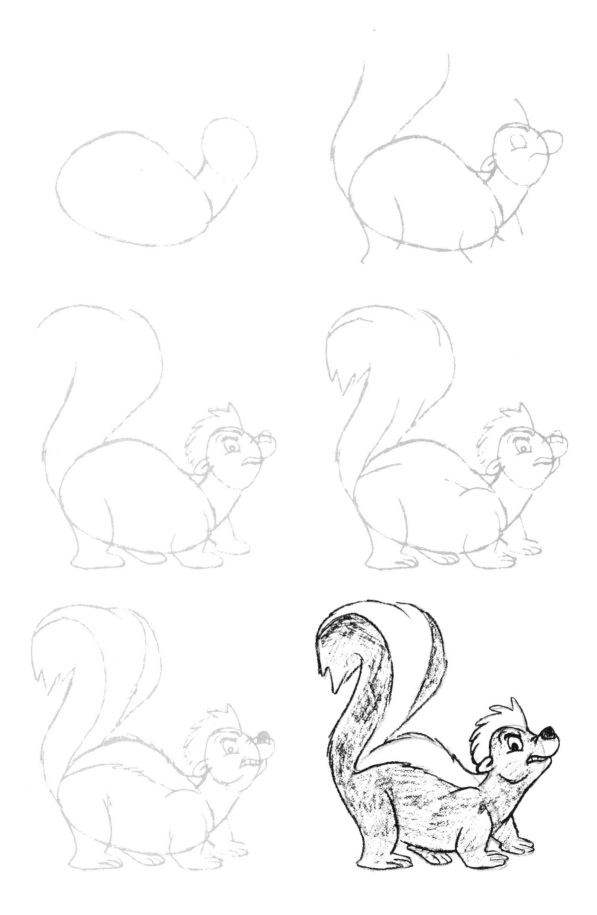

P. U. Polecat

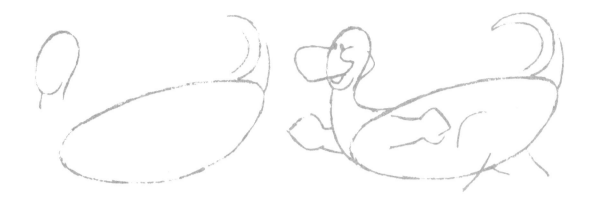

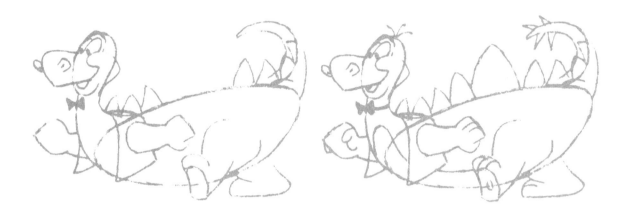

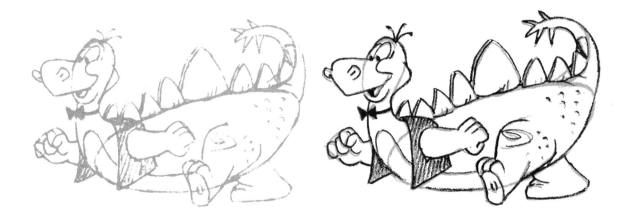

Steggy Sore Izz

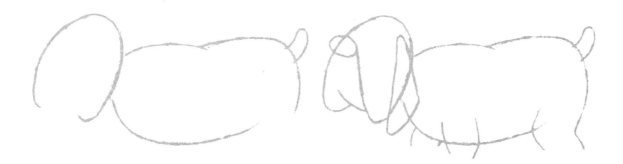

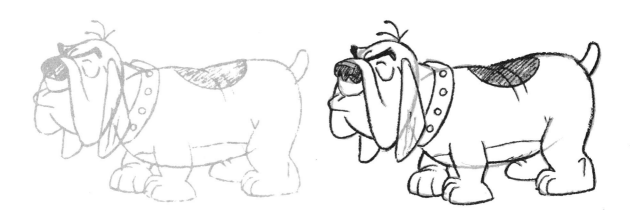

Winston Arrrf

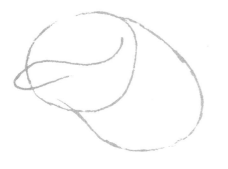
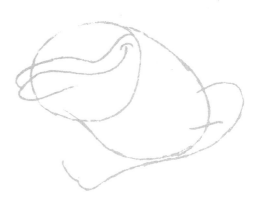
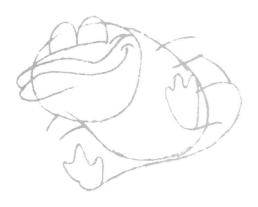
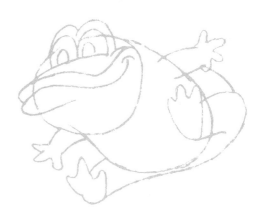
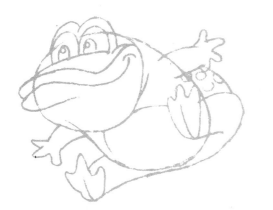
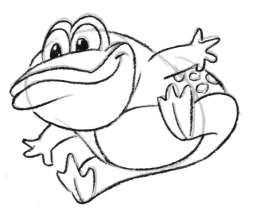

Jumpy Jed, the Bog Frog

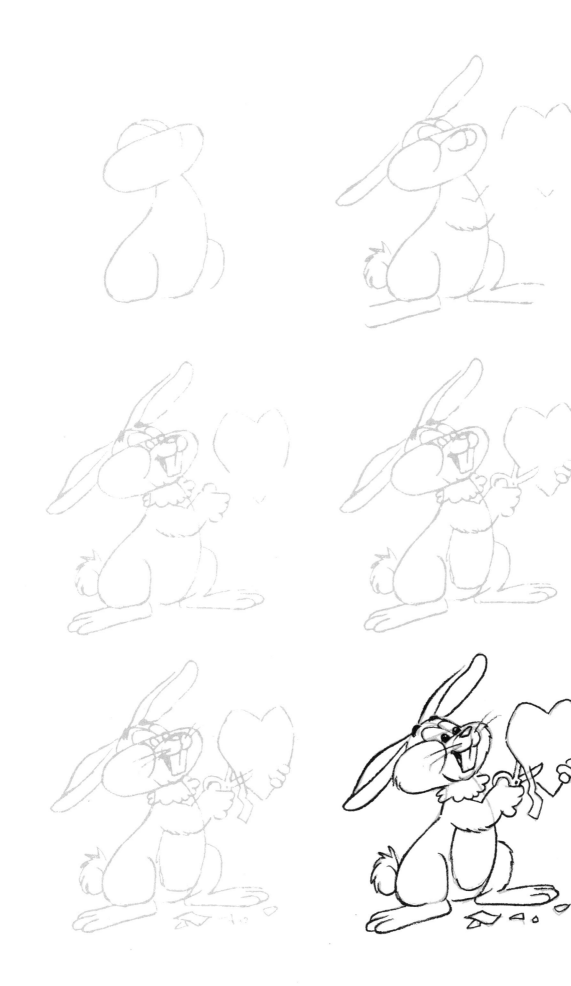

Cottontail Cutup

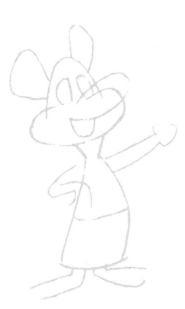
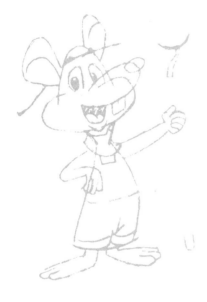
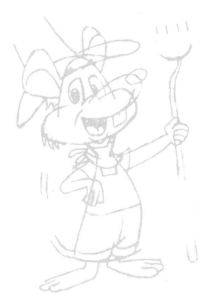
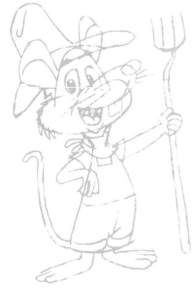
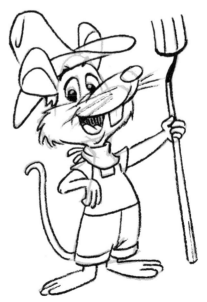

Caleb, the Country Mouse

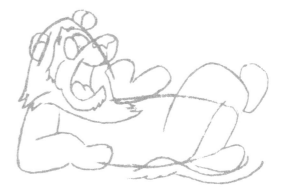
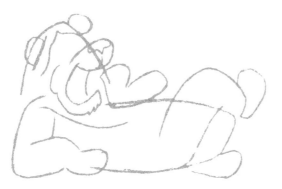
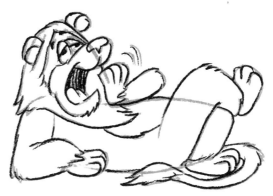
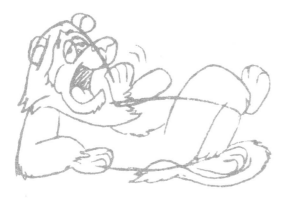

Lazy Leo

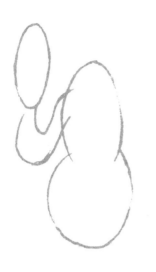
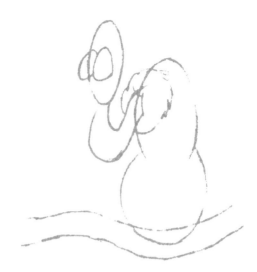
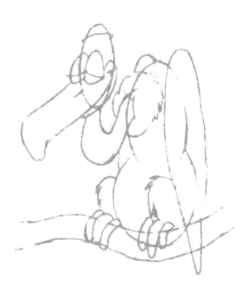
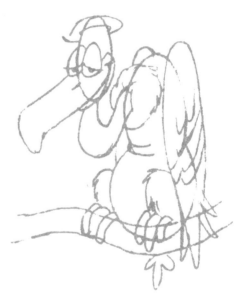
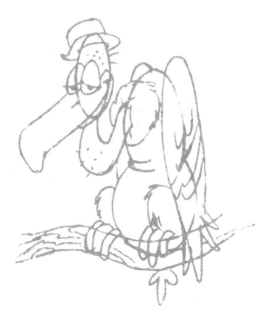
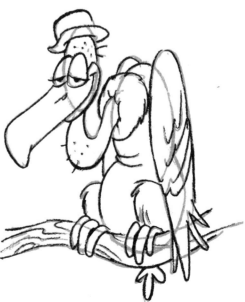

Caspar Condor

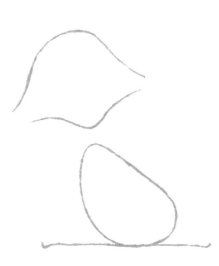
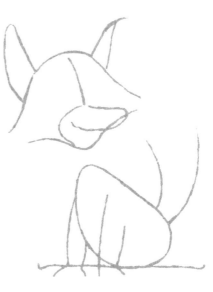
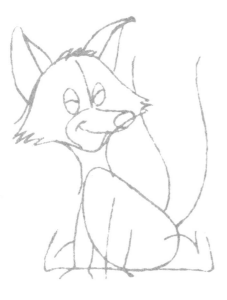
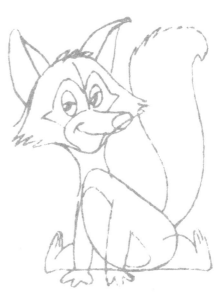
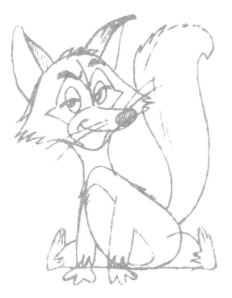
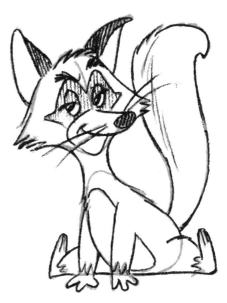

Tricky Ricky, the Fiddly Fox

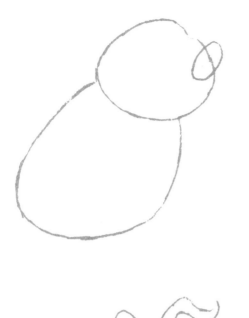
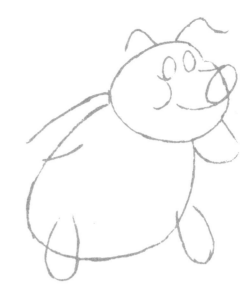
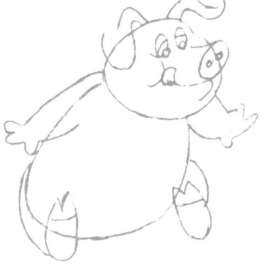
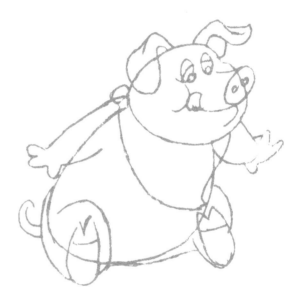
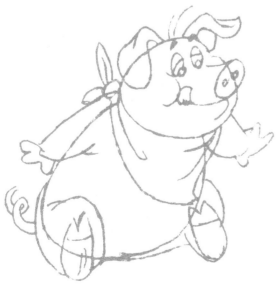
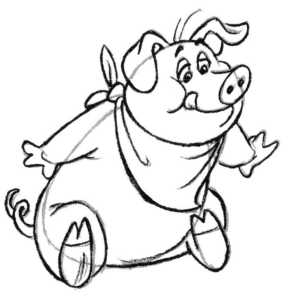

Munchie Millie

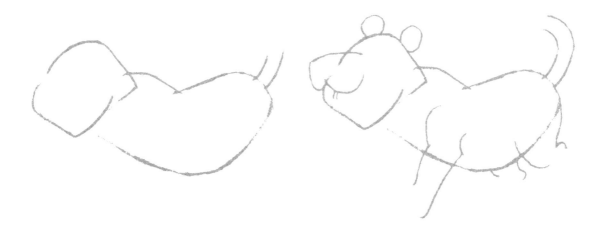

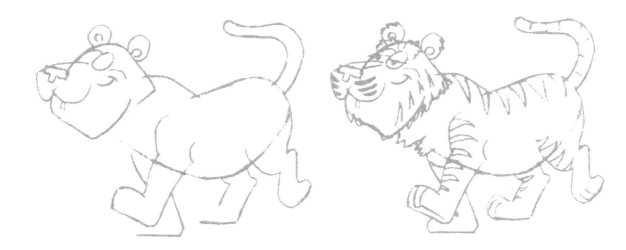

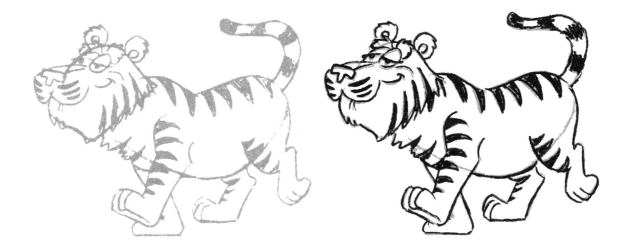

Stripes, the Trendy Tiger

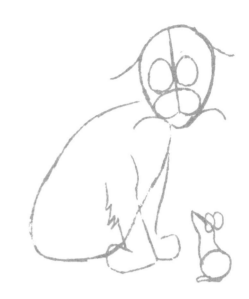

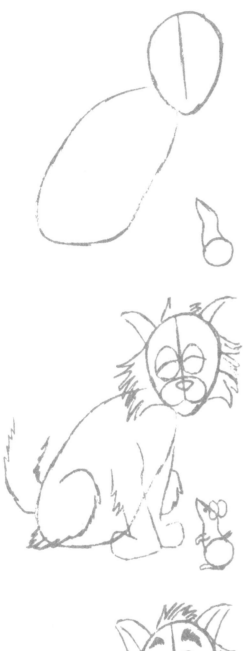

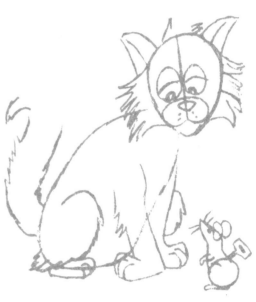

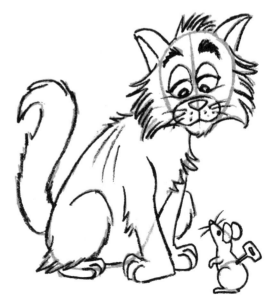

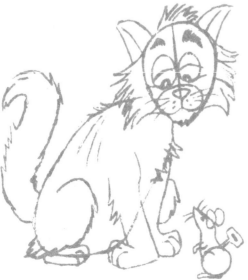

Taken Aback Tabby and Windup Wendell

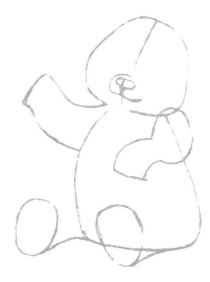
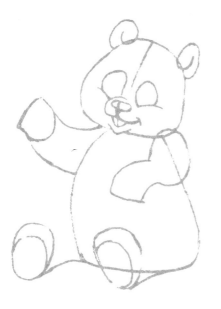
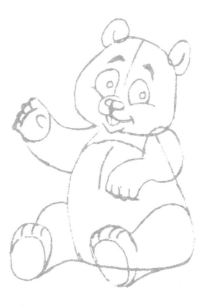
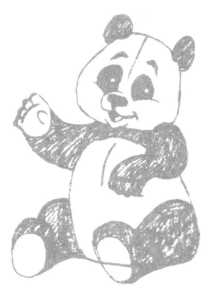
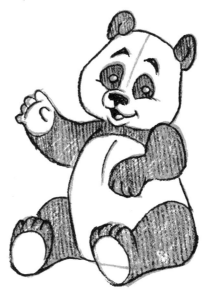

Amanda Panda

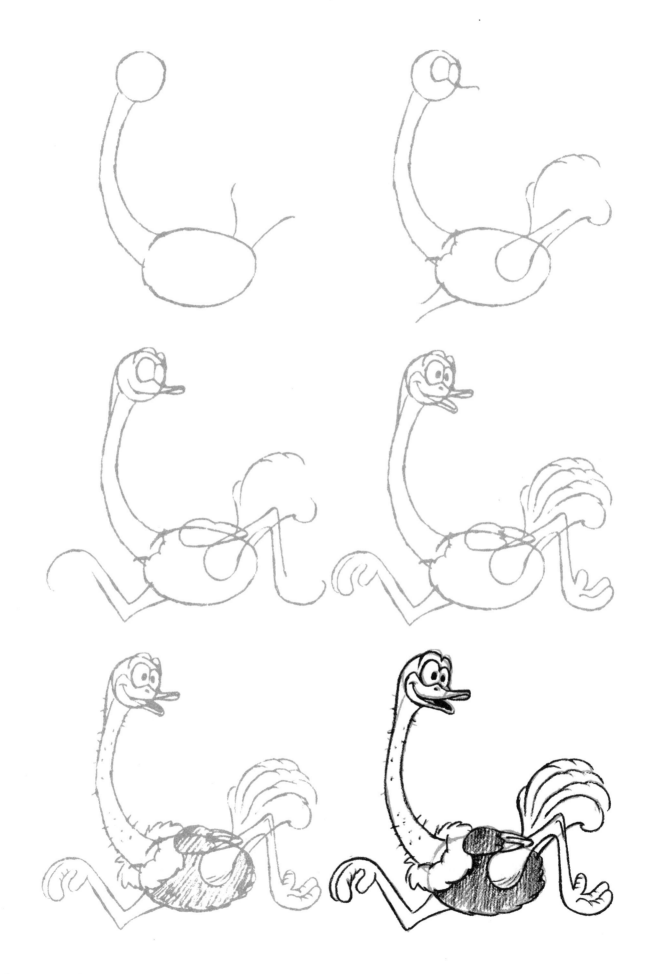

Olga Stretch

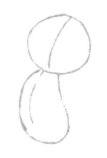
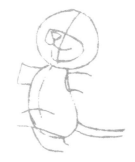
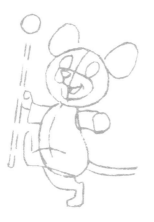
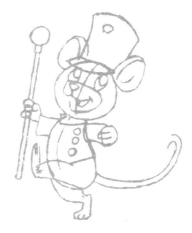
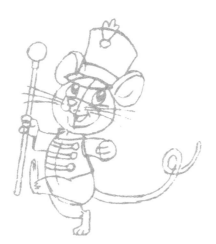
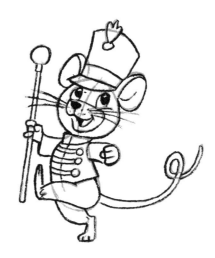

Martial Major Mouse

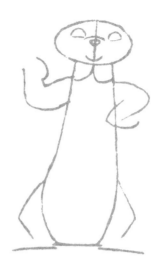
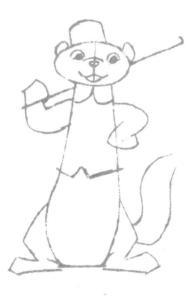
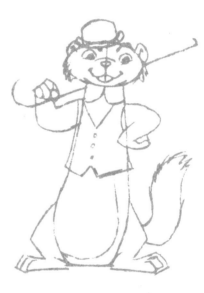
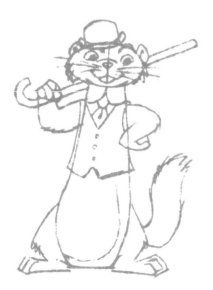
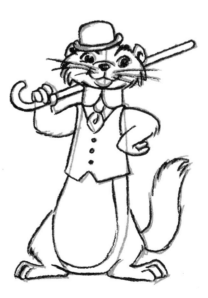

Wily Willy Weasel

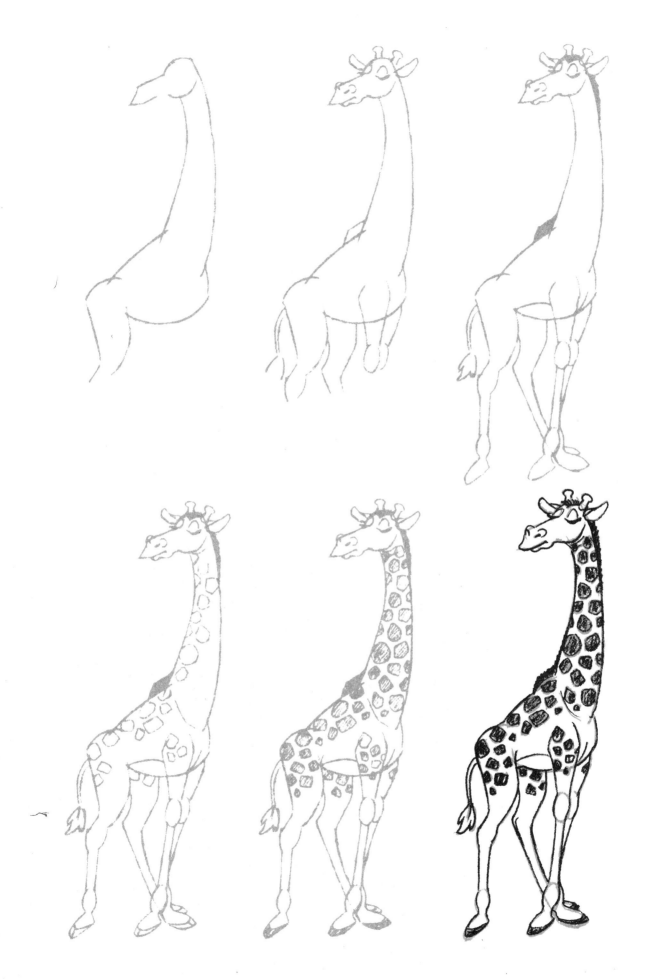

Lengthy Lenny Spots

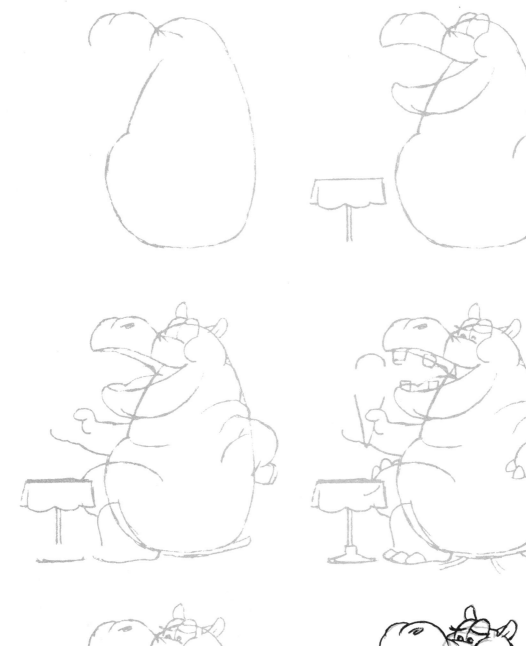

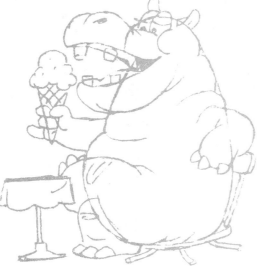
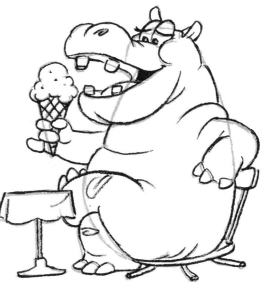

Happy Potta Mess

Lee J. Ames began his career at the Walt Disney Studios, working on films that included *Fantasia* and *Pinocchio*. He taught at the School of Visual Arts in Manhattan, and at Dowling College on Long Island, New York. An avid worker, Ames directed his own advertising agency, illustrated for several magazines, and illustrated approximately 150 books that range from picture books to postgraduate texts. He resided in Dix Hills, Long Island, with his wife, Jocelyn, until his death in June 2011.

DRAW 50 ANIMAL 'TOONS

Experience All That the Draw 50 Series Has to Offer!

With this proven, step-by-step method, Lee J. Ames has taught millions how to draw everything from amphibians to automobiles. Now it's your turn! Pick up the pencil, get out some paper, and learn how to draw everything under the sun with the Draw 50 series.

Also Available:

- *Draw 50 Animals*
- *Draw 50 Athletes*
- *Draw 50 Baby Animals*
- *Draw 50 Cars, Trucks, and Motorcycles*
- *Draw 50 Cats*
- *Draw 50 Dinosaurs and Other Prehistoric Animals*
- *Draw 50 Dogs*
- *Draw 50 Famous Cartoons*
- *Draw 50 Flowers, Trees, and Other Plants*
- *Draw 50 Horses*
- *Draw 50 Monsters*
- *Draw 50 People*
- *Draw 50 Princesses*
- *Draw 50 Sharks, Whales, and Other Sea Creatures*
- *Draw 50 Vehicles*
- *Draw the Draw 50 Way*